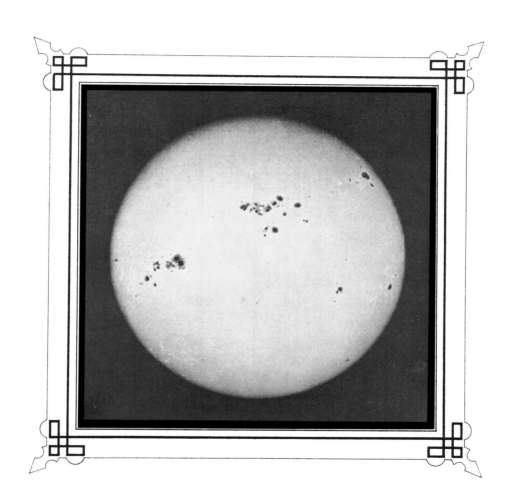

Seeing Things

FRAENKEL GALLERY

San Francisco

With the approach of the gallery's fifteenth anniversary I began to set aside photographs that might chart the dimensions of our particular interest in the art. Since our doors first opened in 1979, with successive exhibitions of work by Carleton Watkins, Lee Friedlander, and lunar photographs from the files of NASA, our net has been cast wide over the history of photography. So rather than choose images to illustrate a specific theme, I decided simply to select pictures that somehow **seemed right,** and let those pictures define their own subject. It soon became apparent that while the photographs were not linked by any common thread of interest in dramatic incidents, famous people, or sublime landscapes, they nevertheless shared a recurrent tone. What bound them together was the sense of serious looking.

The fifty photographs collected here share an intensity of gaze that sometimes approaches the quality of a vision or trance. (This curious aspect of certain photographs is as resistant to analytical explanation today as it was at the time of photography's invention.) Some were made by artists with conscious aesthetic intent, others by scientists or talented amateurs who knew a good subject when they saw one. Yet each possesses such a compelling certainty about its subject that we are led to reconsider the ways by which we come to terms with material fact. And this calls for a greater willingness to pay attention than the pace of late twentieth-century life generally encourages.

People tend to look at photographs quickly. This may be due to the incessant bombardment by photographic images in our lives virtually every hour of the day, or to a deep-rooted suspicion that something "made" in a fraction of a second may not require much longer than that to understand. It may also come down to the plain fact that many photographs simply do not reward prolonged or repeated study. Whatever the reason, this self-protective habit of photographic speed-reading sometimes causes us to pass over those anomalous pictures that resist quick interpretation and whose meanings are not given up so readily. The photographs that follow are of this more reticent sort, and if we heed their quiet call we might also perceive the pure, sensual pleasure inherent in the act of seeing things.

A picture to start: Talbot's *Articles of Glass,* from the first moments of photography's conception, a concise inventory of transparency, revelling in the medium's peculiar descriptive powers. Wisps of light defining clarity.

A picture to end: Hiroshi Sugimoto's *North Atlantic Ocean,* a limitless sweep of water and sky, irrefutable, resistant to haste, taking the measure of our willingness to see.

JEFFREY FRAENKEL

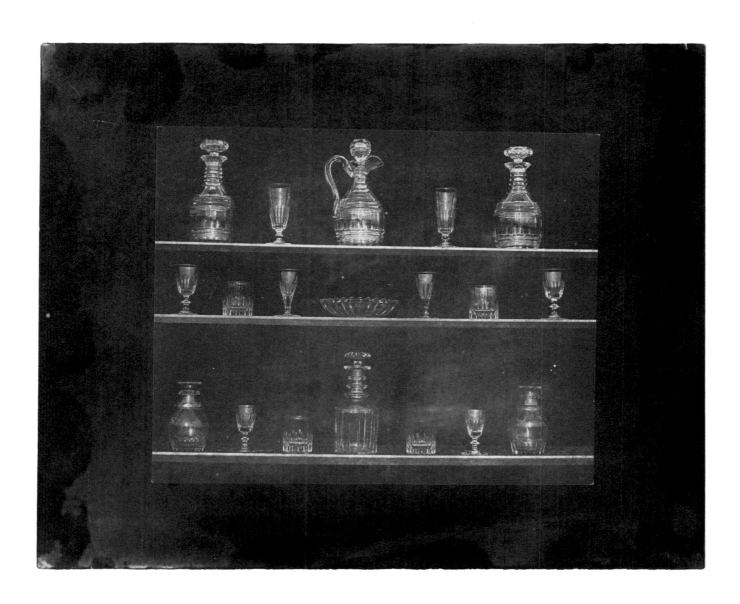

Anna Atkins
Achrosticum Alcicorne,
Greenhouse Halstead
ca. 1851
cyanotype
13½ x 9⅜″

Achrosticum alcicorne.
(Greenhouse Halstead).

3

JOHN B. GREENE
Burial Mound, Algeria
1855-56
salt print from paper negative
10⅛ X 12¾″

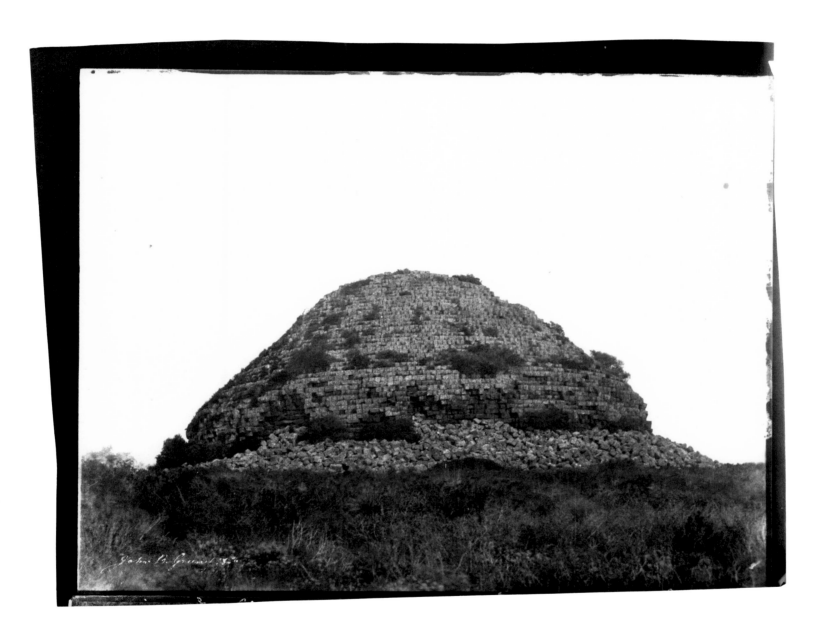

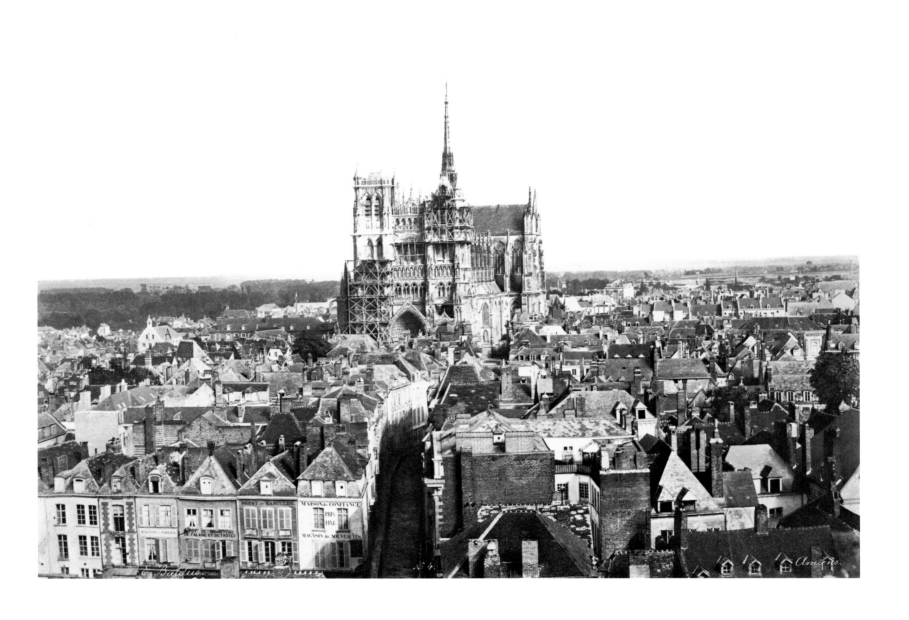

<u>5</u>

Nadar

Honoré Daumier

1855

salt print from paper negative

9⅝ x 7″

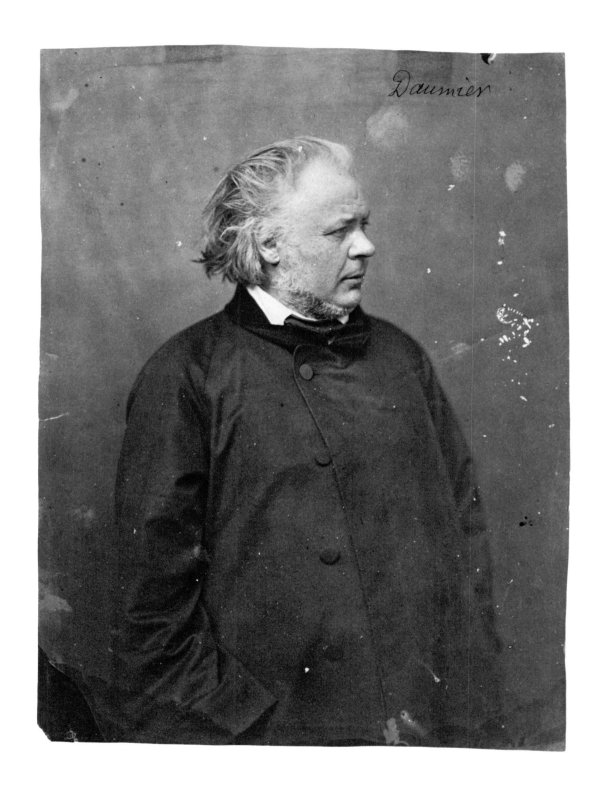

Daumier

GUSTAVE LE GRAY
The Pont du Carrousel, Paris: View to the
West from the Pont des Arts
1856–58
albumen print from glass negative
15 x 18¾″

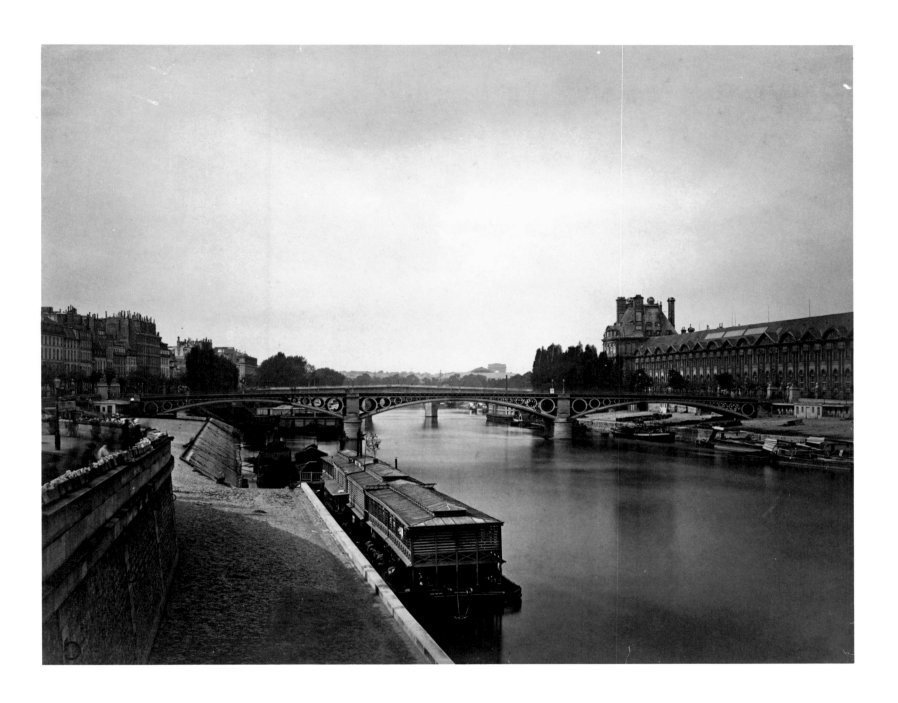

GEORGE N. BARNARD
Ruins of the R.R. Depot, Charleston, S.C.
1865
albumen print from glass negative
10 x 14¼″

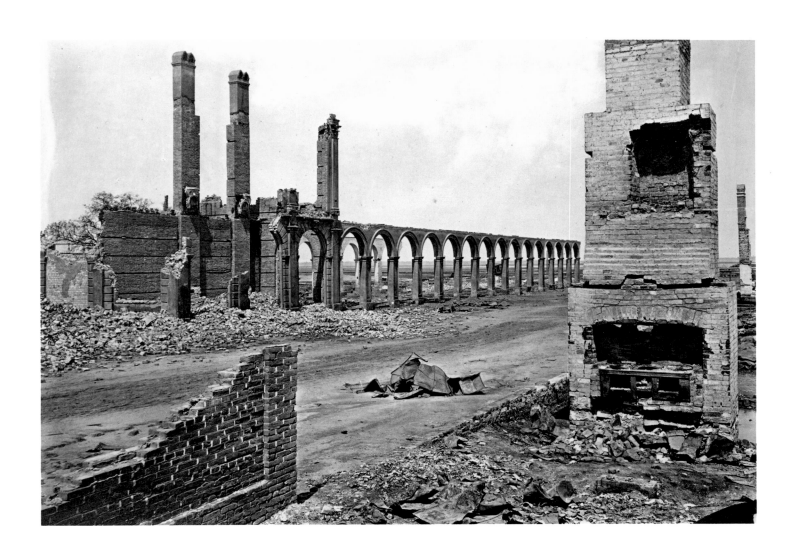

CHARLES CLIFFORD
Seville: Court of the Maidens in the Alcázar
1862
albumen print from glass negative
16⅞ x 12⅝″

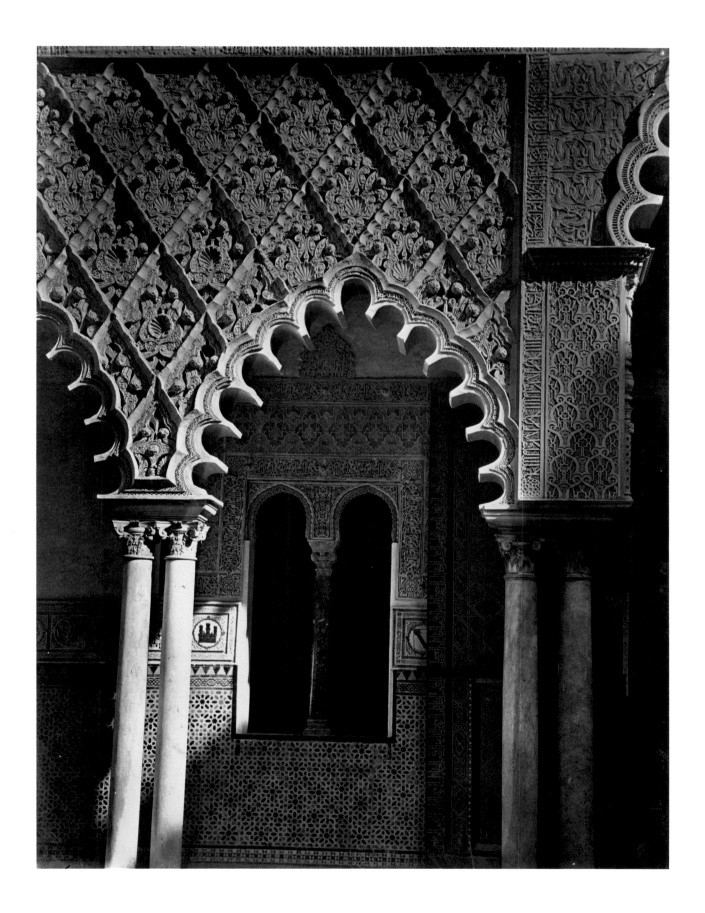

LEWIS CARROLL
Xie Kitchin
ca. 1870
albumen print from glass negative
4¼ x 5⅜″

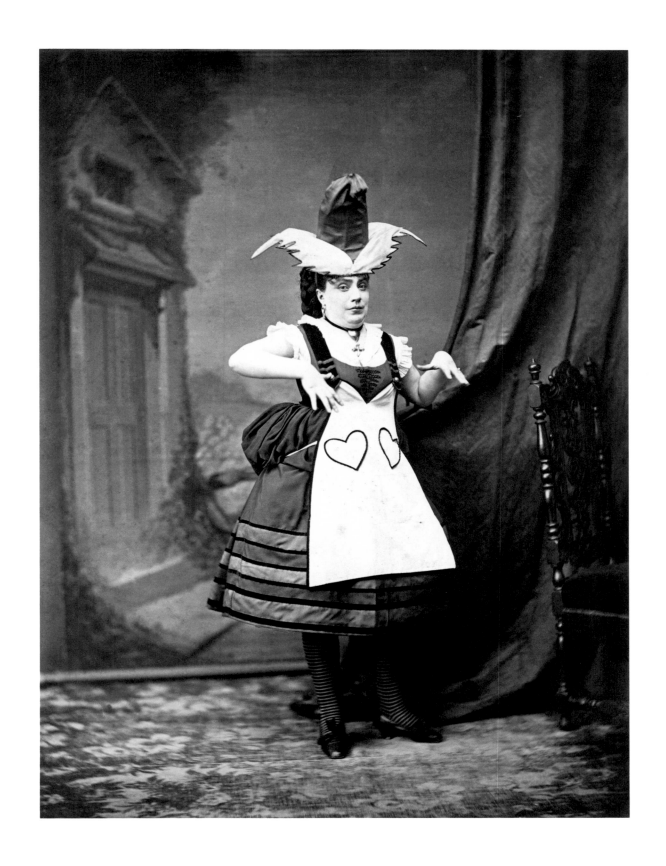

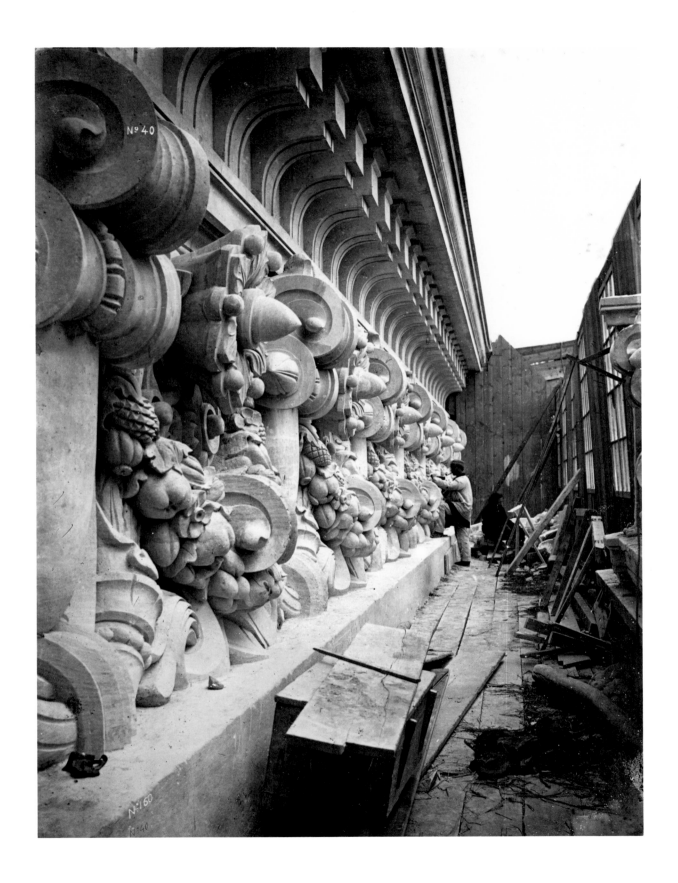

CARLETON E. WATKINS
Cape Horn, Columbia River
1867
albumen print from glass negative
20⅝ x 15⅞″

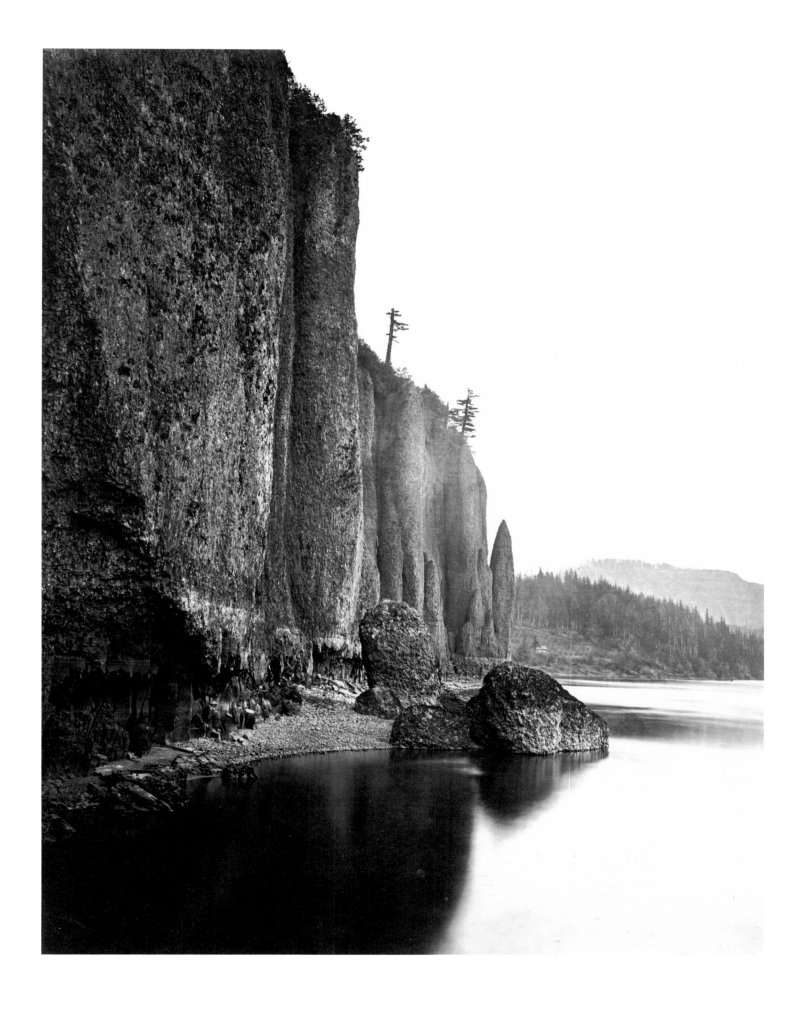

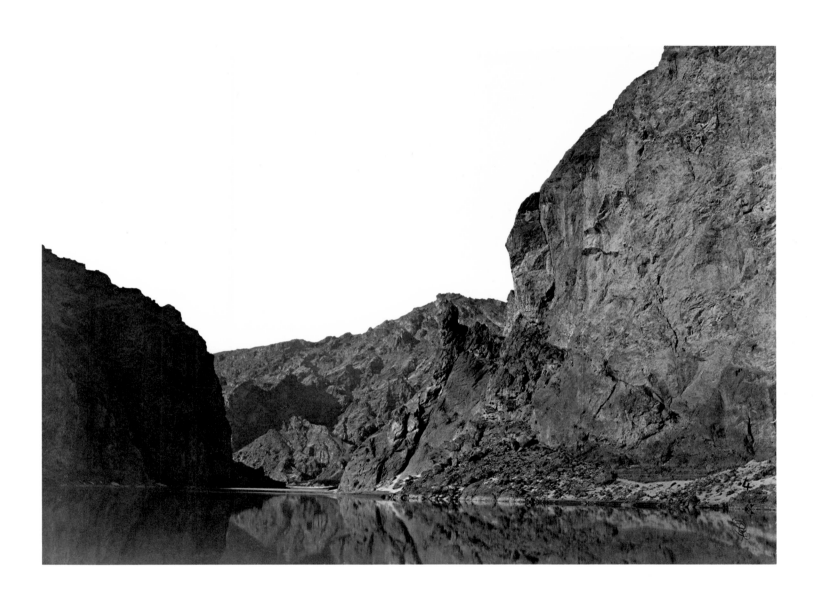

14
EADWEARD MUYBRIDGE
*Valley of the Yosemite from
Sandy Run*
1872
albumen print from glass negative
17 X 21½″

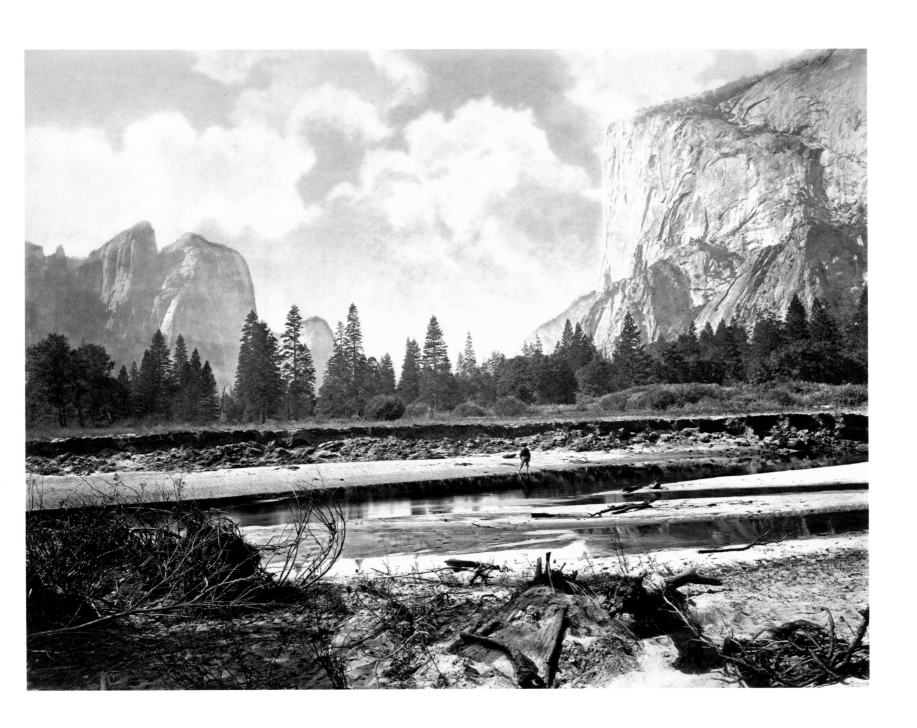

GIORGIO SOMMER
Geological Formation, Ischia
ca. 1875
albumen print from glass negative
7⅜ x 10″

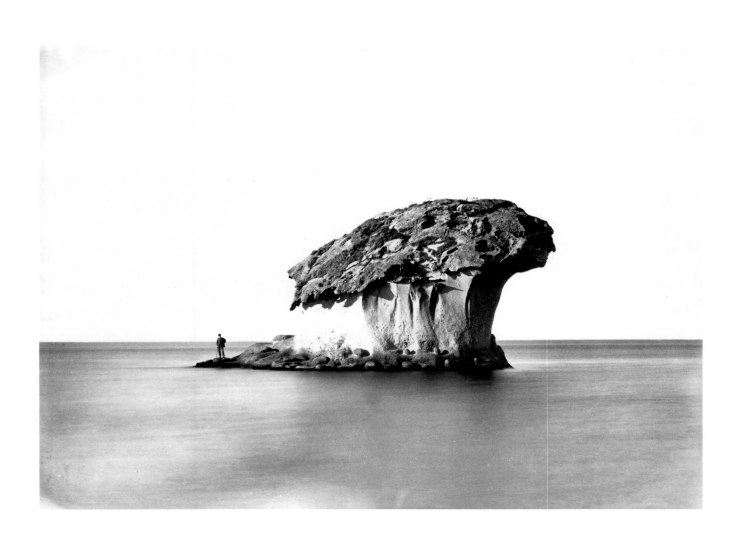

PHOTOGRAPHER UNKNOWN
Balloonist
ca. 1910
gelatin-silver print
2⅛ x 3¼″

J. MILTON OFFORD
Corona & Surrounding Regions
April 22, 1901
gelatin-silver print
6¼ x 8⅛″

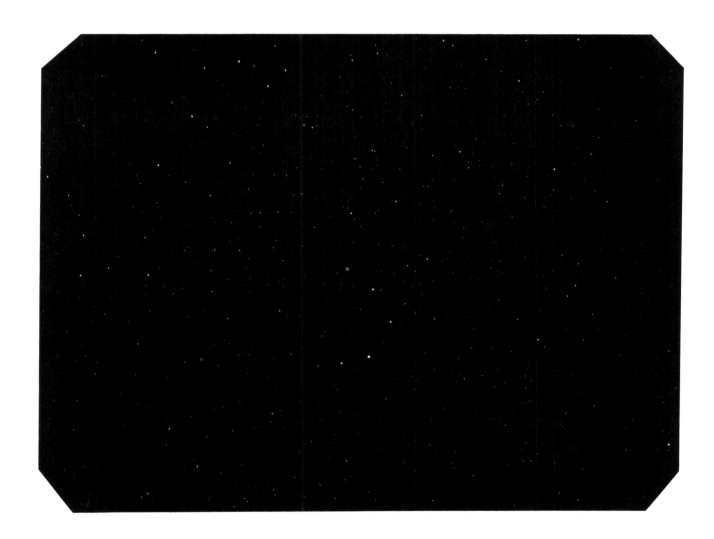

Attributed to CHARLES BREED
Untitled
ca. 1915
gelatin-silver print
5⅜ x 3⅜″

<u>19</u>

E. J. BELLOCQ
Untitled (Storyville Portraits)
ca. 1912
two silver prints from glass negatives
10 x 8″ each

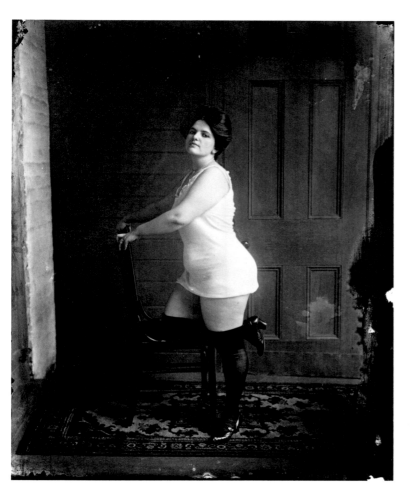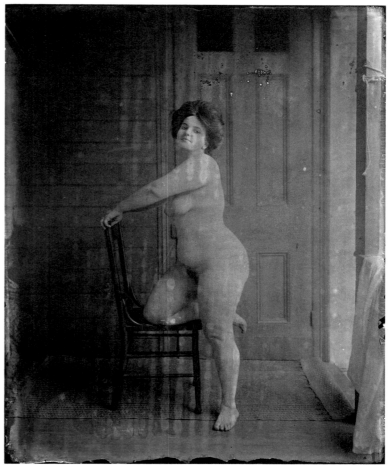

EUGÈNE ATGET
Magasins du Bon Marché
1926–27
silver print from glass negative
7 x 9″

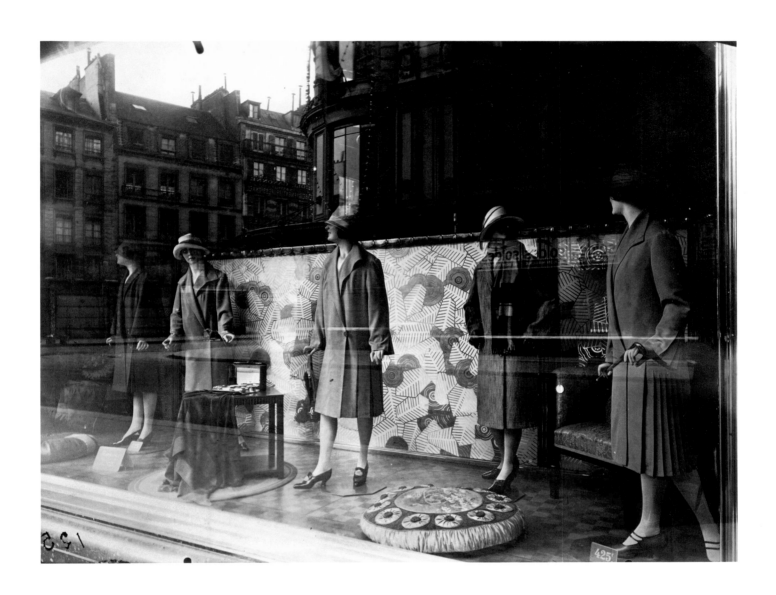

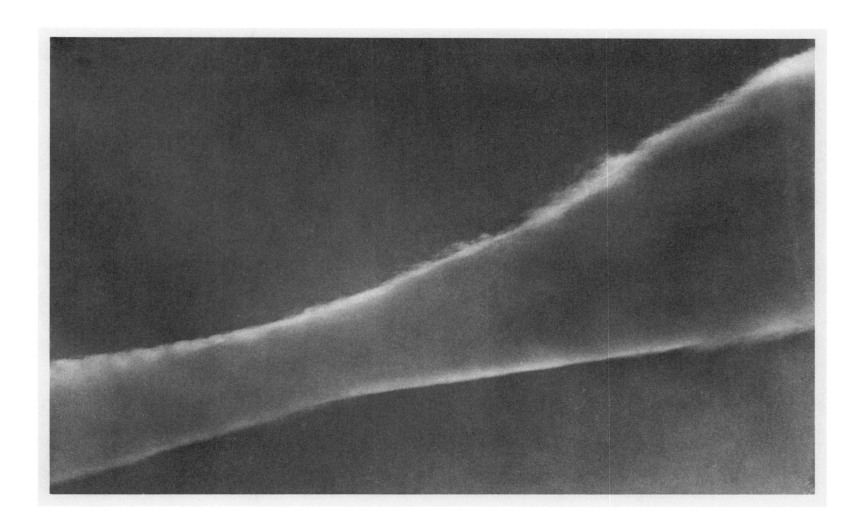

LÁSZLÓ MOHOLY-NAGY
7 A.M. (New Year's Morning)
ca. 1930
gelatin-silver print
19⅞ x 15¾″

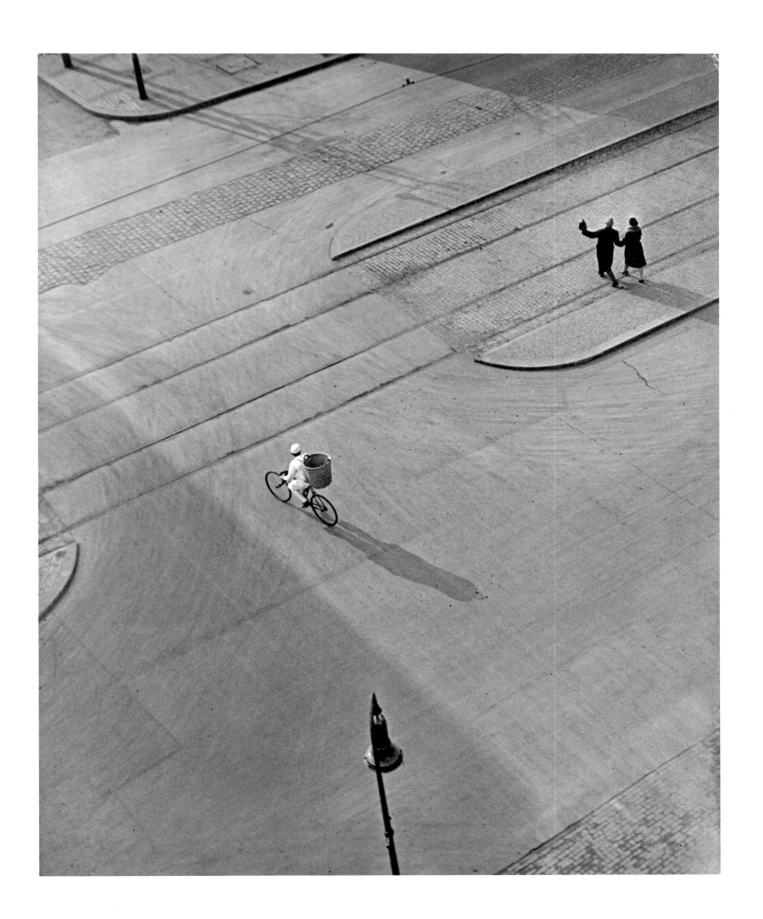

AUGUST SANDER
The Painter Heinrich Hoerle, Cologne
ca. 1928
gelatin-silver print
10¼ x 7⅞"

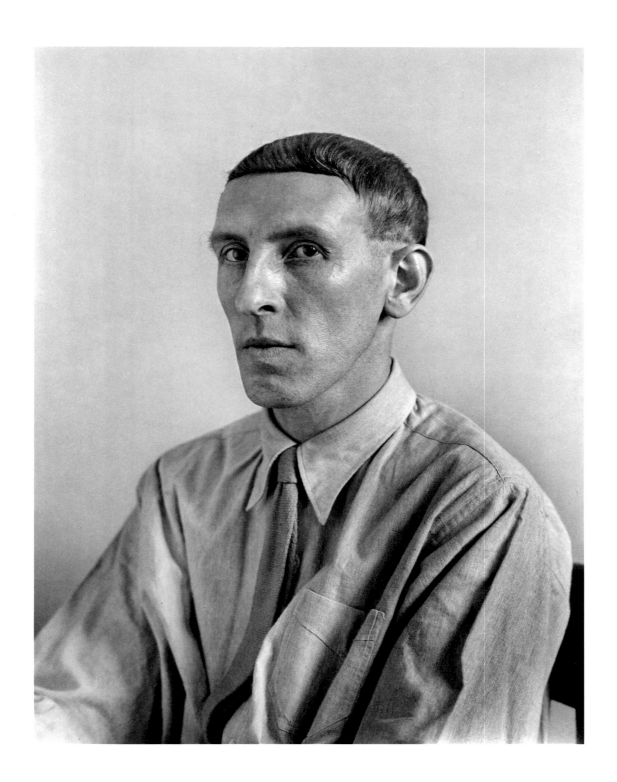

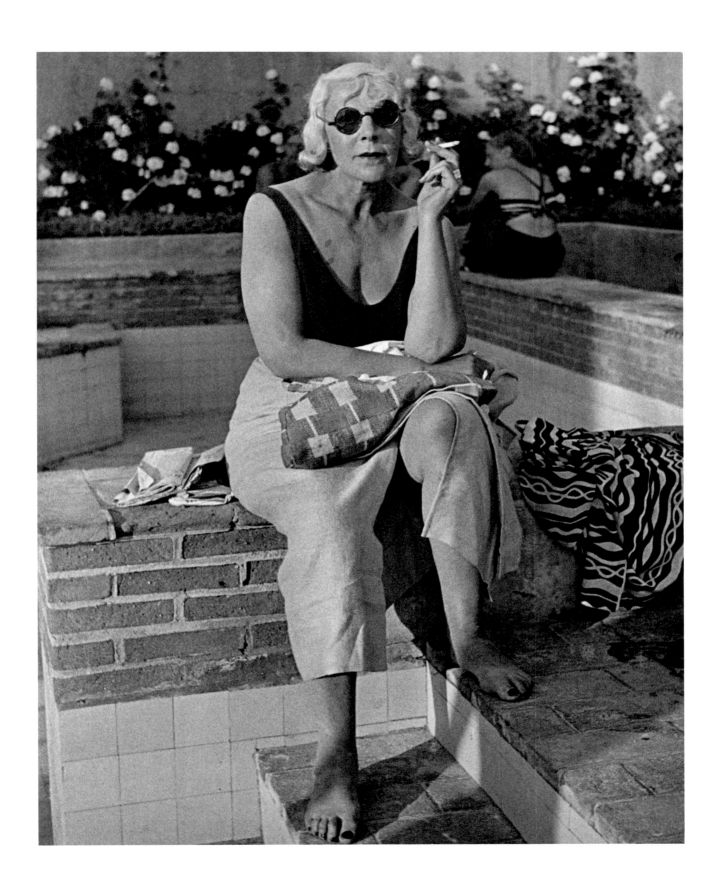

BERENICE ABBOTT
504-506 Broome Street, New York
1935
gelatin-silver print
7⅛ x 9½″

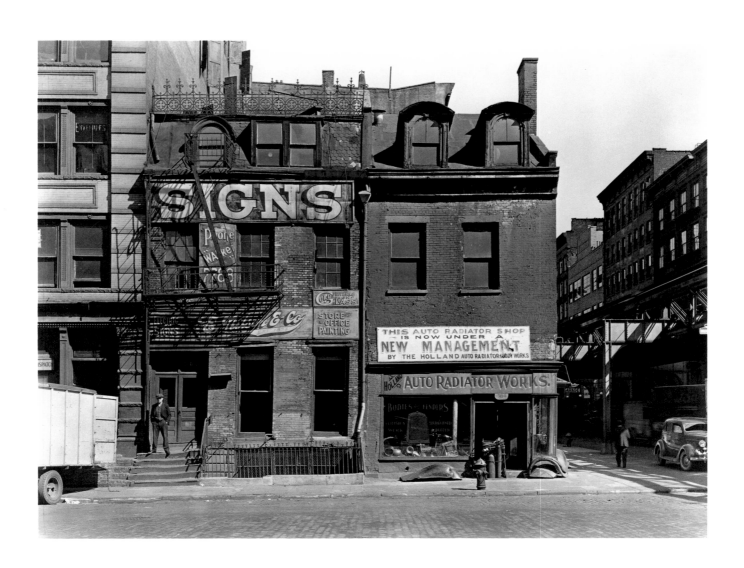

IRVING PENN
Optician's Window, New York
1939
gelatin-silver print
8¾ x 6⅞″

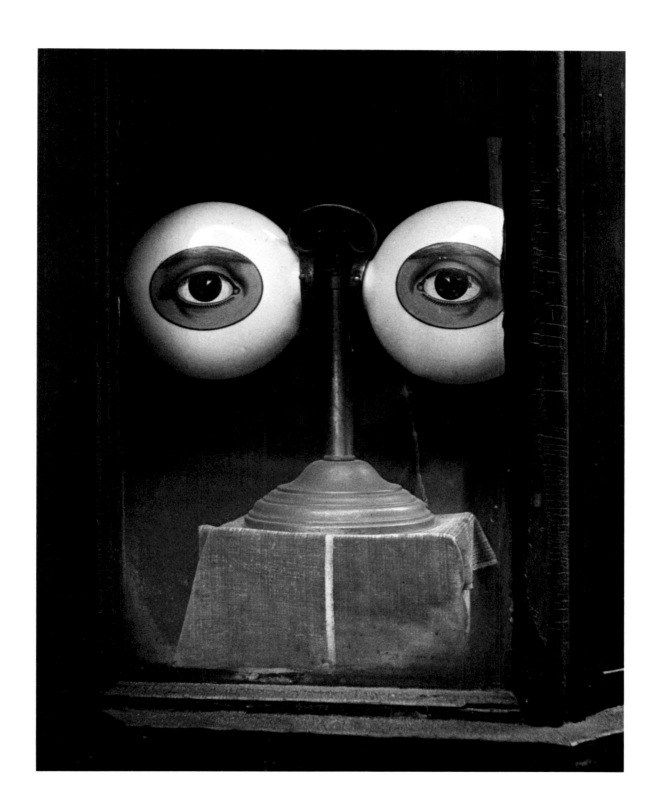

DR. HAROLD E. EDGERTON
Milk Drop
1935
two gelatin-silver prints
4⅝ x 6⅜″ each

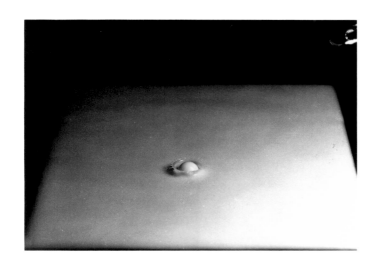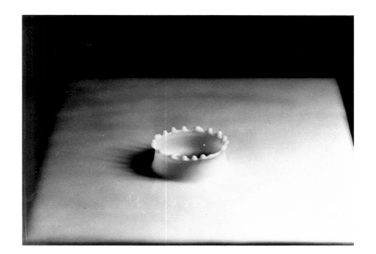

FREDERICK SOMMER
Glass
1943
gelatin-silver print
7⅝ x 9½″

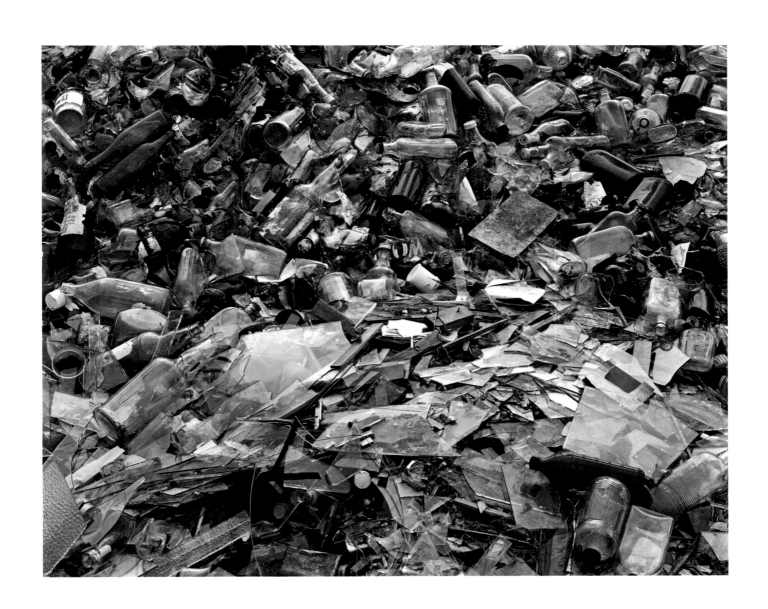

HARRY CALLAHAN
Detroit
1941
gelatin-silver print
3¼ x 4⅜″

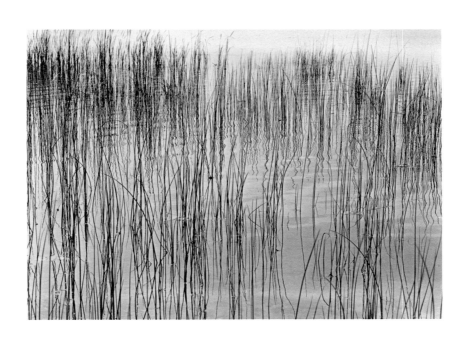

DOROTHEA LANGE
The Road West, New Mexico
1938
gelatin-silver print
10⅛ x 13¼"

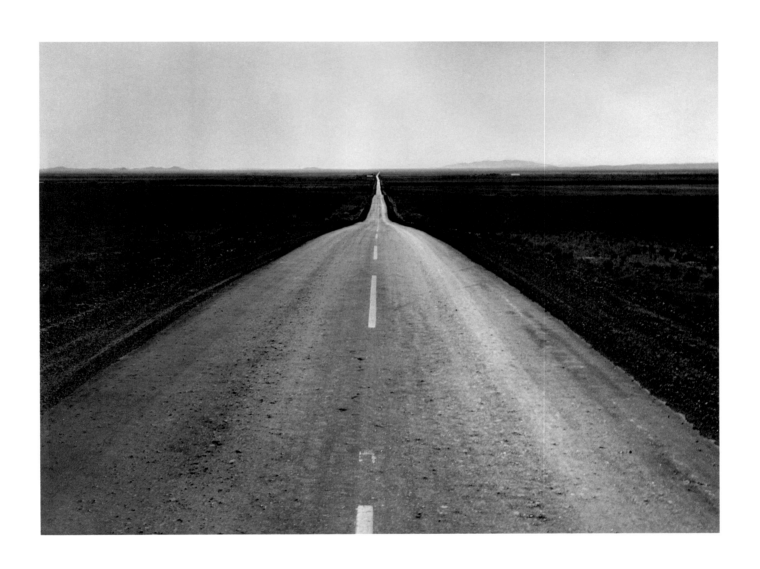

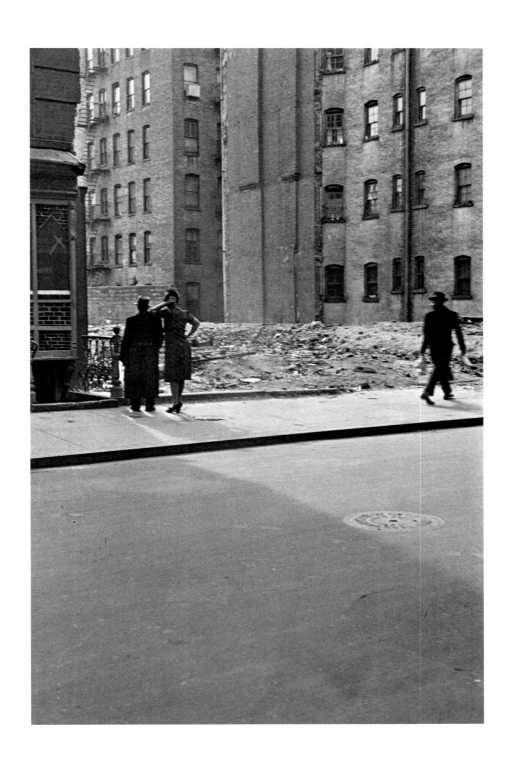

34

ROBERT FRANK
34th Street, New York City
1948
gelatin-silver print
13⅜ x 8⅝″

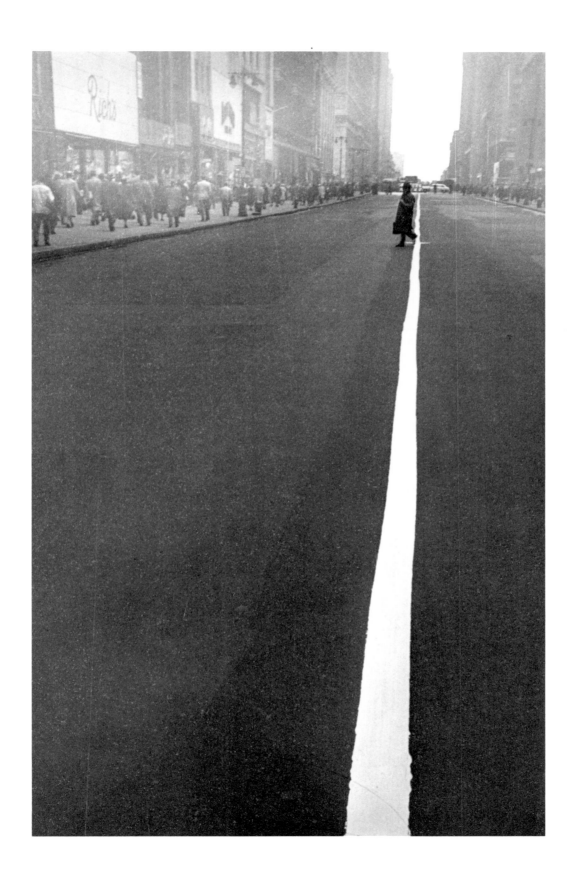

LEE FRIEDLANDER
Florida
1963
gelatin-silver print
9⅛ x 6⅛″

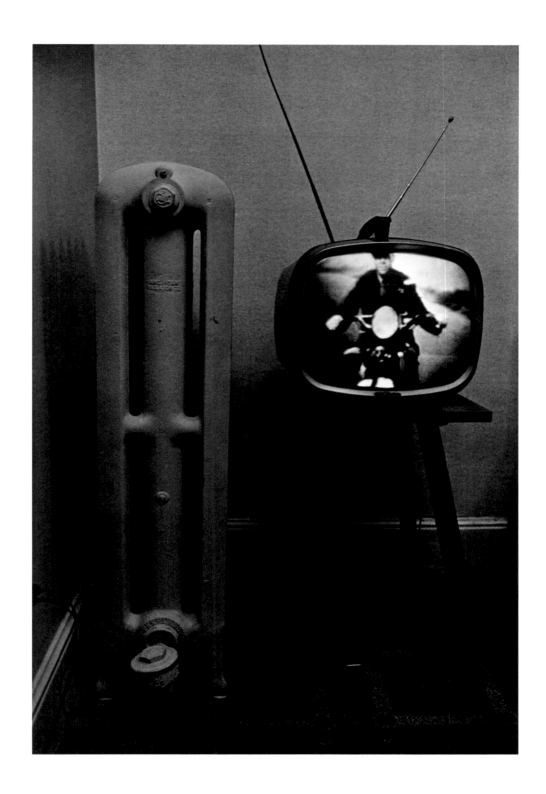

DIANE ARBUS
Xmas Tree in a Living Room in Levittown,
Long Island, NY
1962
gelatin-silver print
10⅛ x 9⅞″

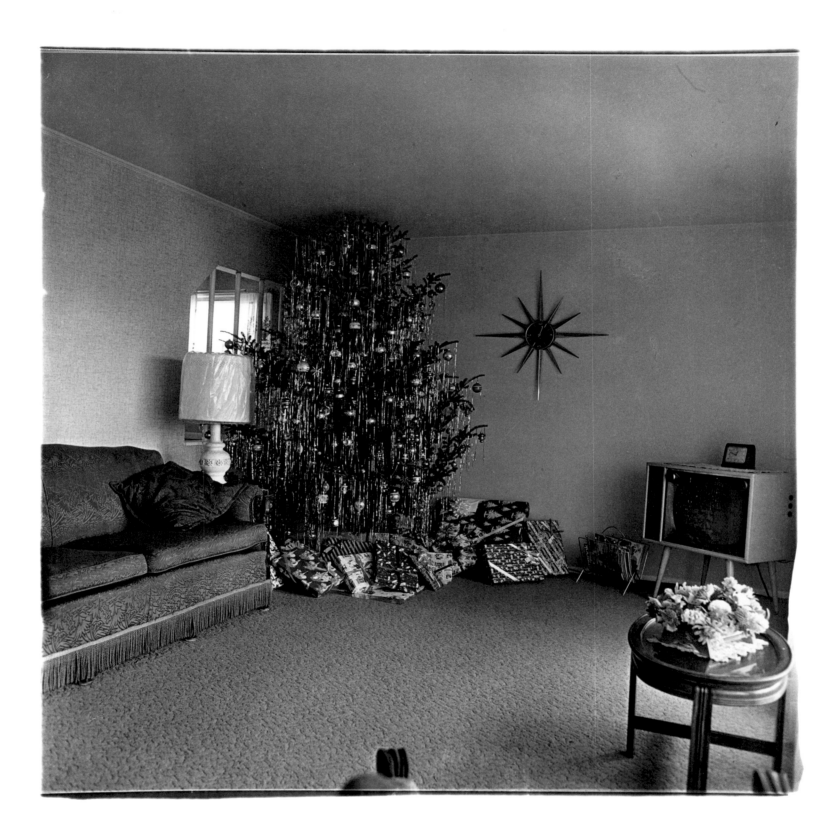

WILLIAM EGGLESTON
Memphis
ca. 1970
dye-transfer print
13¼ X 20⅜″

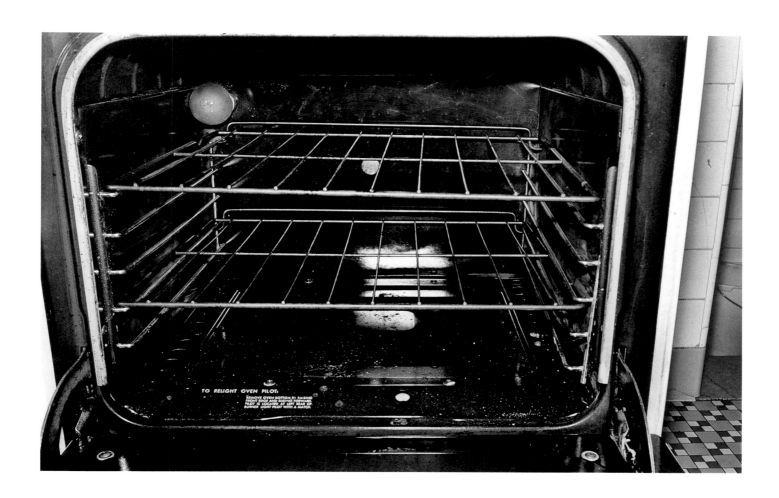

ROBERT ADAMS
Colorado Springs, Colorado
1968
gelatin-silver print
6 x 6″

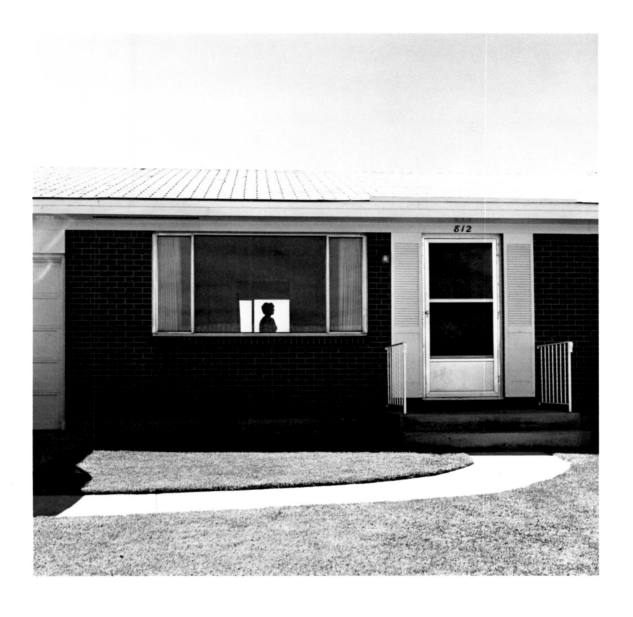

HENRY WESSEL
Santa Barbara, California
1977
gelatin-silver print
11 X 16⅝″

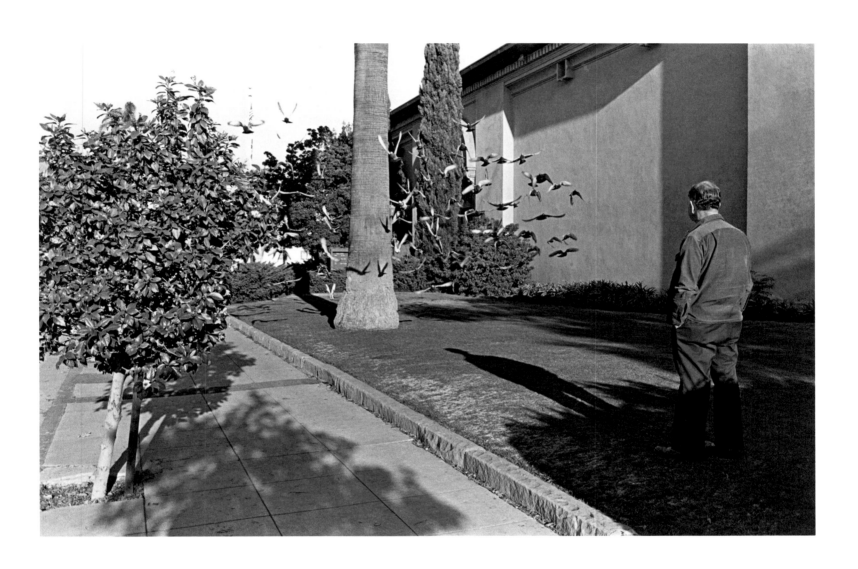

GARRY WINOGRAND
Central Park Zoo, New York City
ca. 1963
gelatin-silver print
13⅛ x 8⅞"

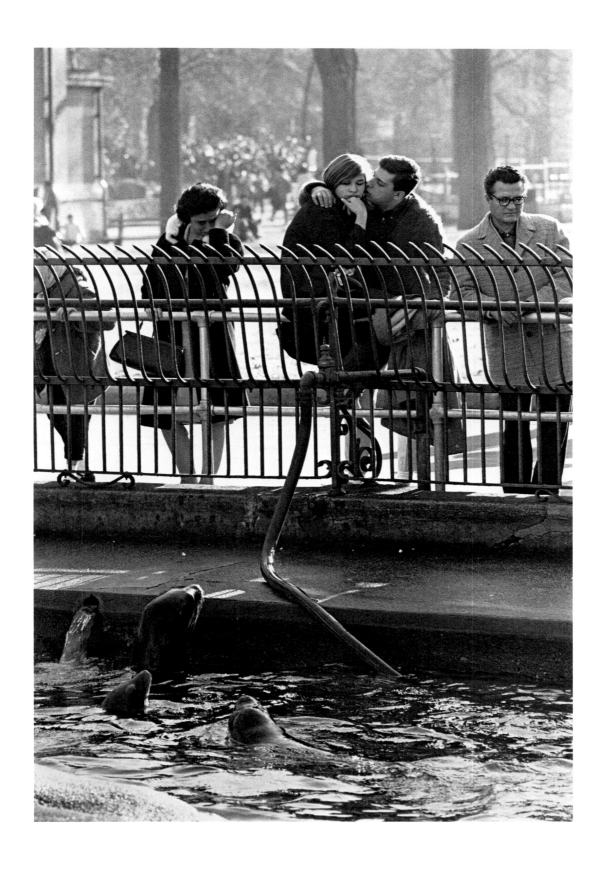

NICHOLAS NIXON
Robert, Ginny, and Bob Sappenfield,
Dorchester, Massachusetts
August 1988
gelatin-silver print
7¾ x 9⅝″

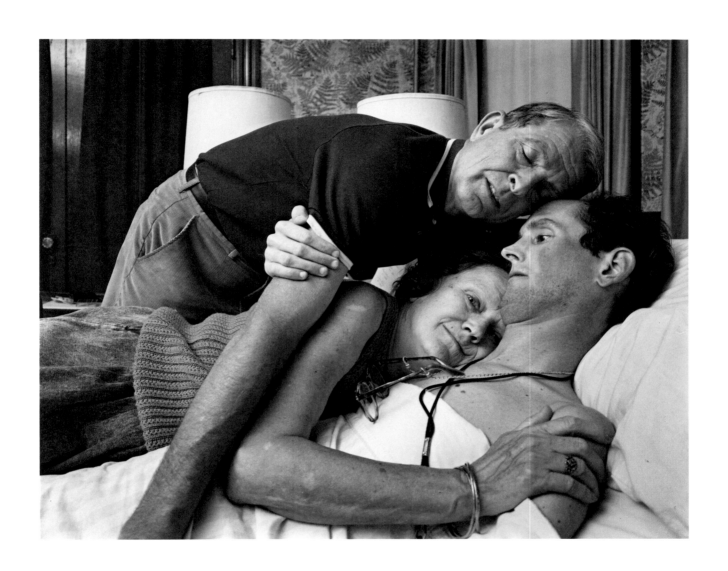

RICHARD MISRACH
Diving Board, Salton Sea
1983
chromogenic color print
17¾ X 22½″

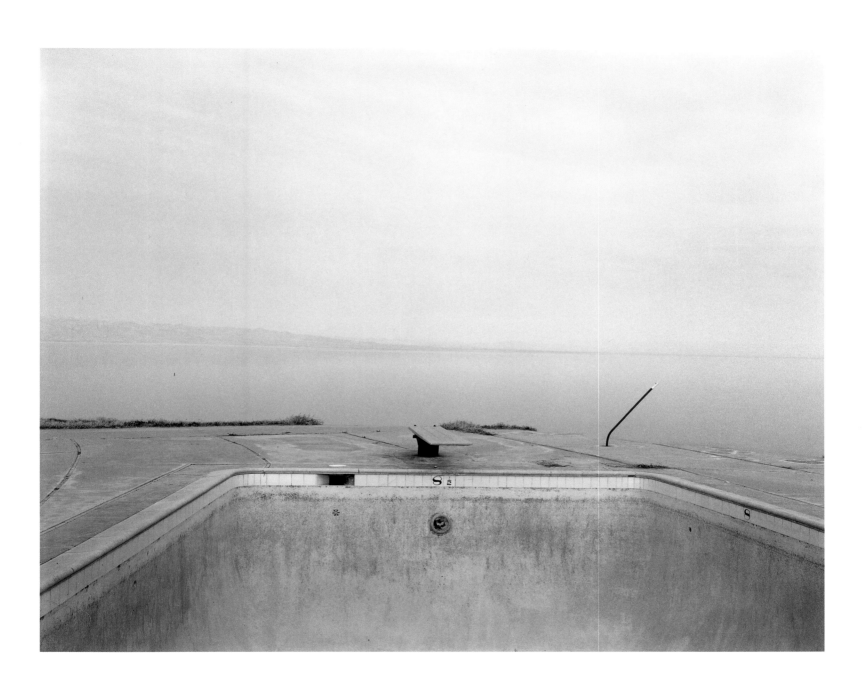

<u>43</u>

BERND & HILLA BECHER
Beziers, Herault, France
1984
gelatin-silver print
23½ x 18⅞"

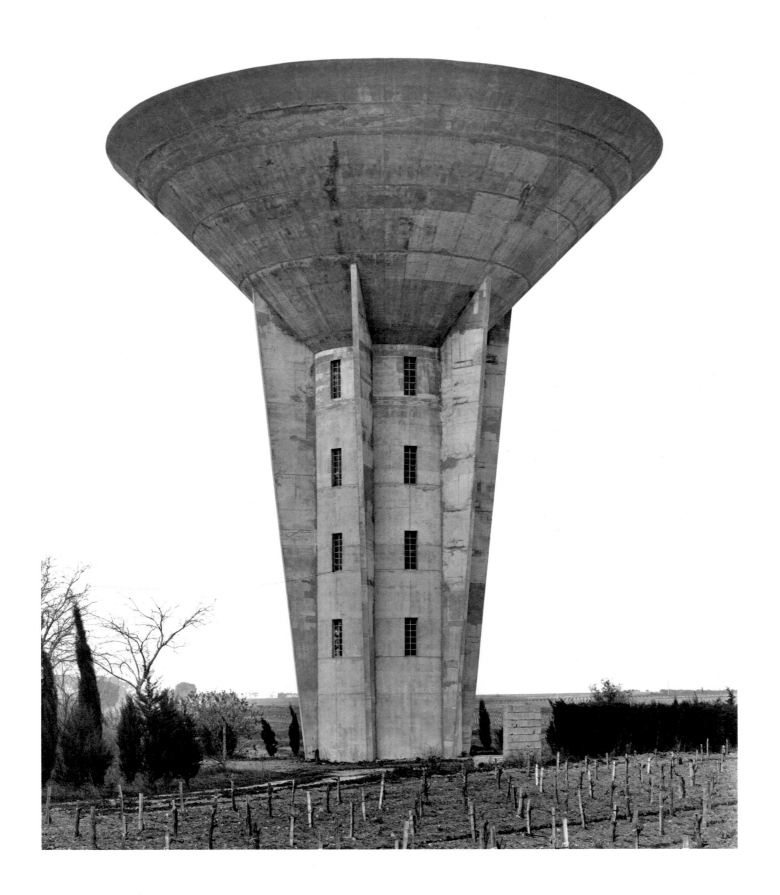

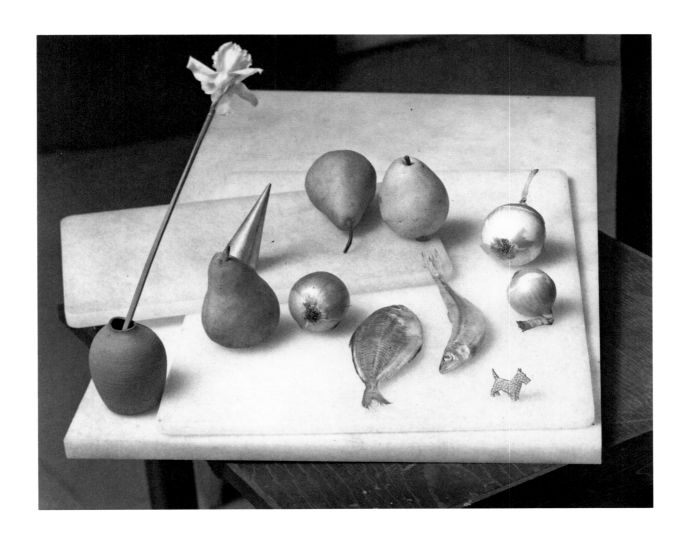

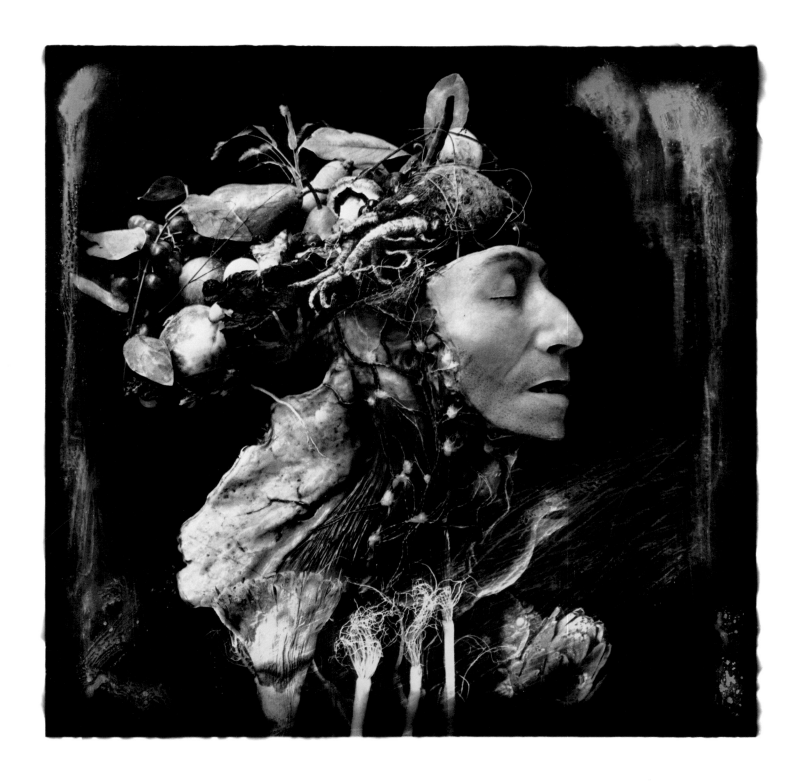

MARK KLETT
Night Storm, Glendale, Arizona
1993
gelatin-silver print
15⅞ x 19¾"

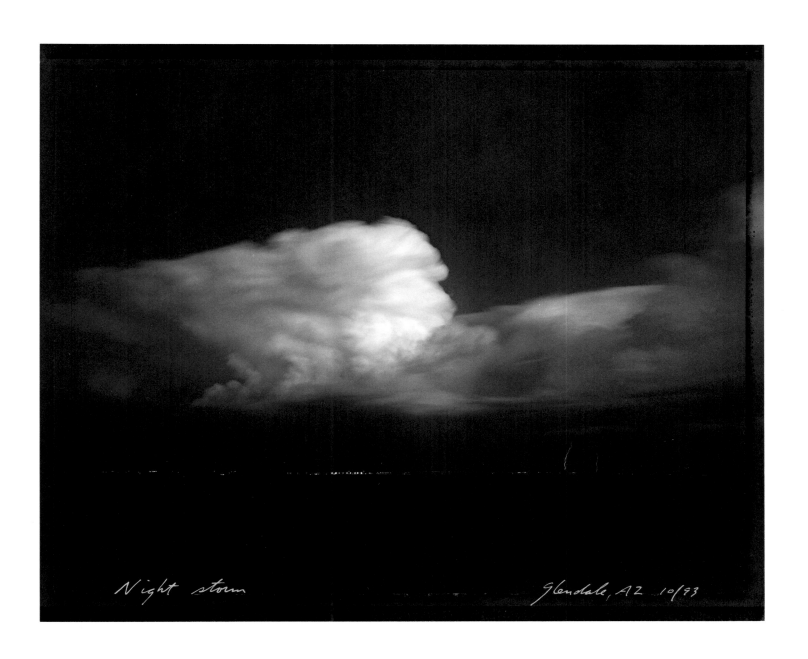

Night storm Glendale, AZ 10/93

WILLIAM WEGMAN
A Silver Tilt
1982
polacolor print
24 x 20⅝″

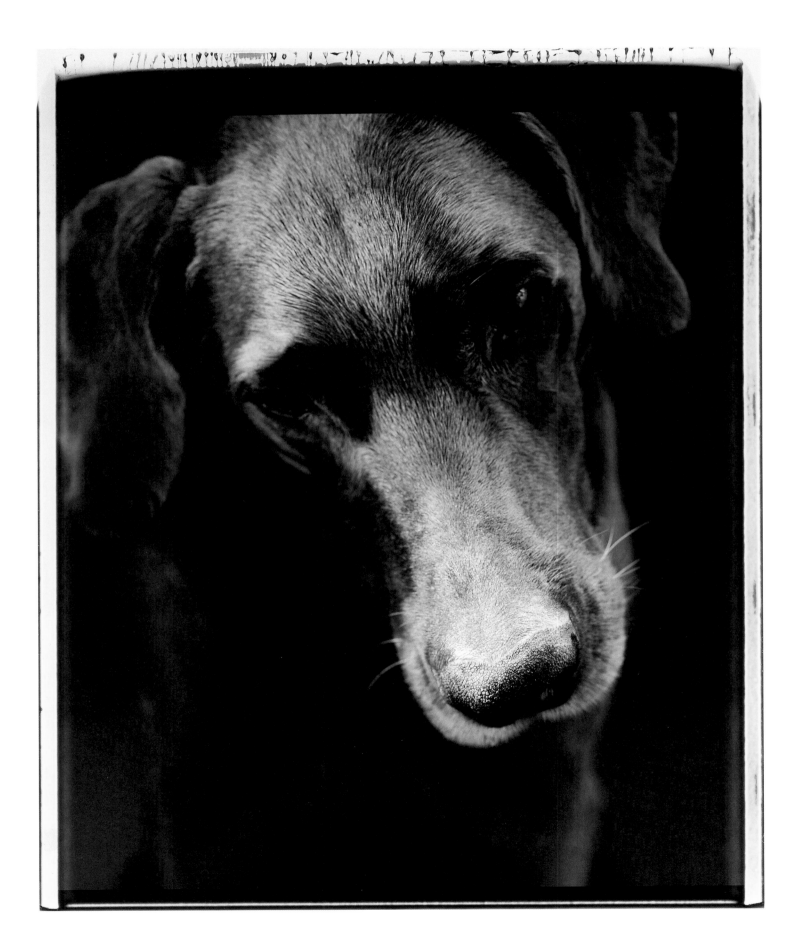

<u>48</u>

ROBERT MAPPLETHORPE
The Coral Sea
1983
platinum print
26 x 22″

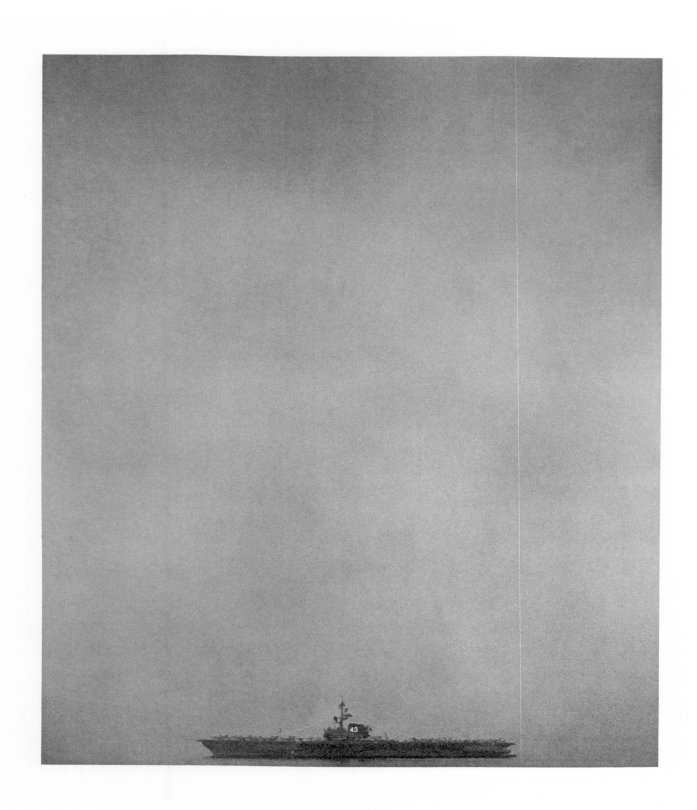

ADAM FUSS
Untitled
1990
gelatin-silver print
23⅜ x 19⅜″

<u>50</u>
HIROSHI SUGIMOTO
North Atlantic Ocean,
Cliffs of Moher
1989
gelatin-silver print
16½ x 21⅜″

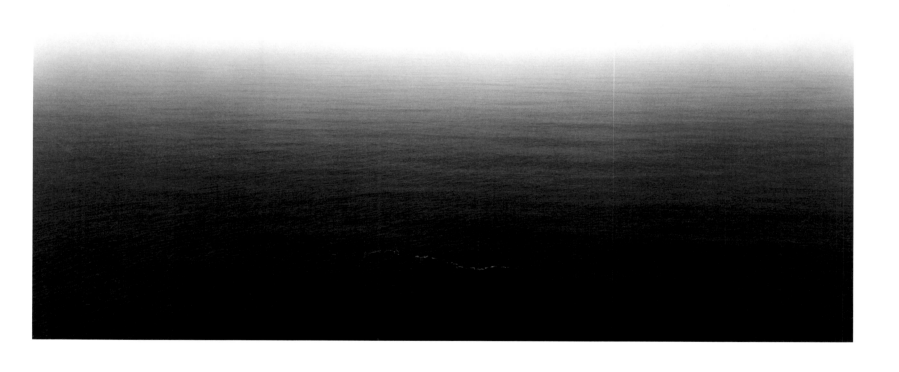